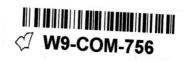

CONTENTS

Plants 3

Animals 9

People 17

Machines 29

The Digital Frame Store 43

Chronology 47

Biography 48

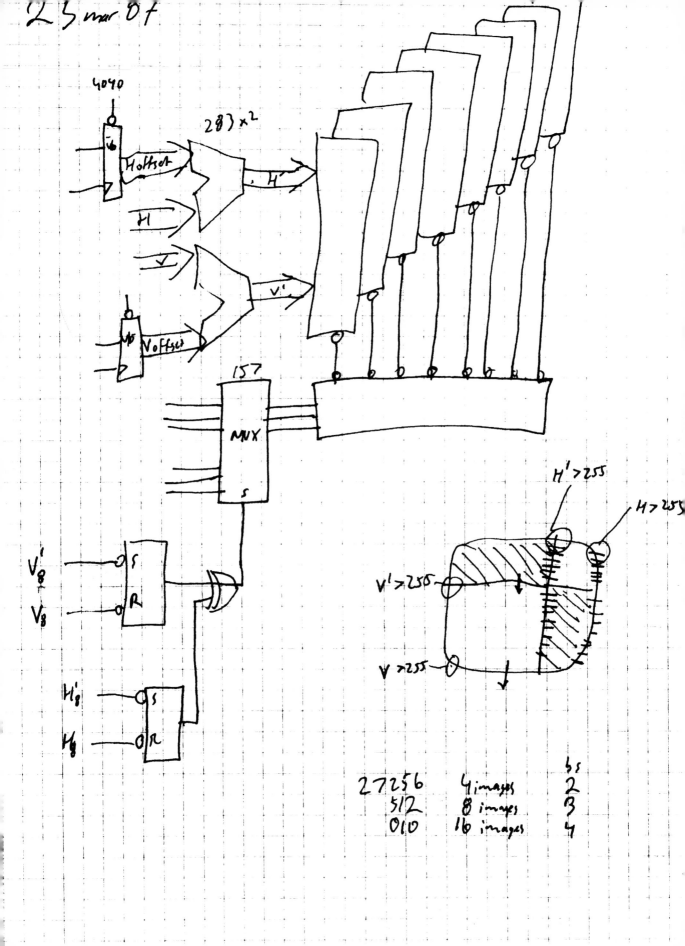

PLANTS

Encountering a room full of Alan Rath's speaker pieces can be a mildly hallucinogenic experience. Are you looking at *Magic Mushrooms* or have you just taken them? Gradually, at the periphery of your consciousness you detect eerie, animate presences. Strange, pulsating black and/or white blossoms perched on the end of long tentacle-like stalks grow in great profusion along the walls, across the ceiling, in old crates, and out of the floor. Amalgams of high and low technology, these sculptures are intriguing hybrids. Part botanical, part anthropomorphic, part machine, they conflate the historically disparate realms of technology and nature in an elemental application of bionics to the plant world. Magically, in Rath's deft hands, industrial detritus is animated with life-force.

Rath is part of the long lineage of twentieth-century sculptors for whom the natural world is a fertile source of imagery. The evocation of nature in Rath's work seems all the more startling, however, since his sculptures are essentially machines, objects usually considered the antithesis of nature. Nevertheless, Rath's technological and electronic components — circuit boards, wires, and speakers — possess an organic quality. In *Giant Wallflower*, for example, the looping wires calligraphically dancing across the wall and the floor are reminiscent of proliferating vines. The speakers are like flowers in full bloom. Indeed, many of Rath's speaker pieces are entitled "wallflowers," a witty wordplay referring both literally to their location on the wall and figuratively to their temperament. True to their name, Rath's "wallflowers" have a shy, retiring disposition; unlike the video pieces that directly confront the viewer, the mechanical flora are more ambient. They are less insistent and aggressive than their image counterparts much in the same way that a houseplant requires less care and attention than does a pet or a human companion.

There are commonalities among all of Rath's sculptures, whether plant, animal, machine, or human. Wires can simultaneously read as electrical conduits, stems, nerve corridors, or parts of the circulatory system. The speakers resemble flowers, yet their vibrations, emitting barely audible sounds, equally suggest a beating heart or breathing lungs. Rath's work posits a parity among all living forms, and by extension, the machine we design in our image. Implicit is the notion that whether anatomical, botanical, digital, or mechanical, everything is organized by the same underlying principles and comparable systems.

Rath's work is a logical outgrowth of his lifelong interests. Early on, he was inspired by the wizardry of rock and roll concerts, and as a youth he built lighting displays and music synthesizers; in fact, one of his speaker pieces, *Jimi's Guitar*, was inspired by his hero Jimi Hendrix. Rath entered the Massachusetts Institute of Technology as a physics major but soon switched to electrical engineering because of his passion for building machines and tinkering with electronics. While at MIT, he experimented at the Visual Language Workshop, the Architecture Machine Group, and the Center for Advanced Visual Studies. These programs, which explored both technology and aesthetics, provided the young student with an alternative to the practical applications of straight engineering and an outlet for his creative energies. Rath has often railed against the hype of technology and the bloated sense of self-importance that the high-tech industry attaches to developing ever more sophisticated and functional products. In Rath, as artist/tinkerer, this hyperrational impulse is humanized. The relentlessness of modern high tech is replaced by the cultivation of his fanciful garden of mechanical plants.

Donna Harkavy
Curator of Contemporary Art
Worcester Art Museum, Worcester, Mass.

PHOTOS:

page 5

Magic Mushrooms, 1990, 73 x 33 x 22 inches. Wood, plastic, aluminum, electronics, six speakers. Private collection: California.

page 6

Giant Wallflower, 1992, 87 x 106 x 31 inches. Aluminum, electronics, six speakers. Private collection: Germany.

page 7

Taipei Wallflower, 1994, 66 x 34 x 8 inches. Aluminum, electronics, five speakers. Private collection: California.

page 8

Off the Wall II, 1989, dimensions variable. Wood, aluminum, electronics, three speakers. Worcester Art Museum, Worcester, Mass. (photo courtesy Worcester Art Museum)
Off the Wall, 1989, dimensions variable. Wood, aluminum, electronics, three speakers.

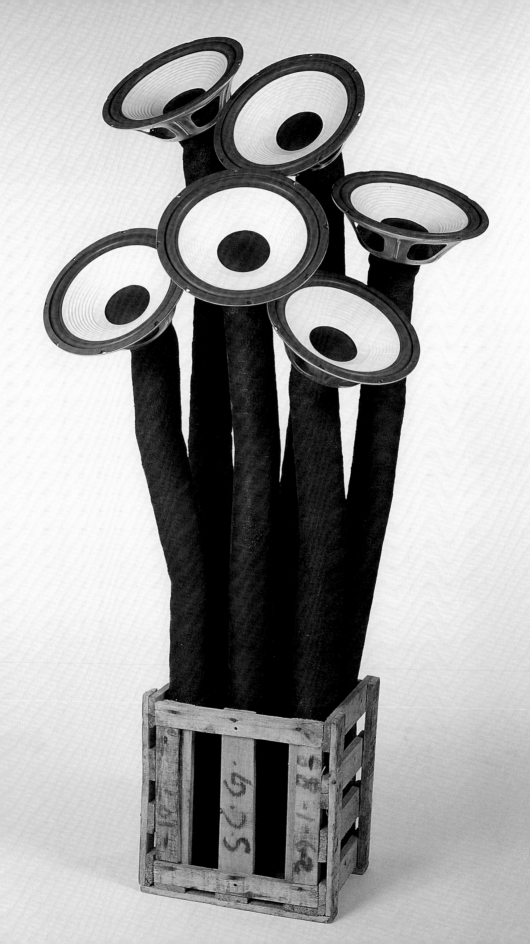

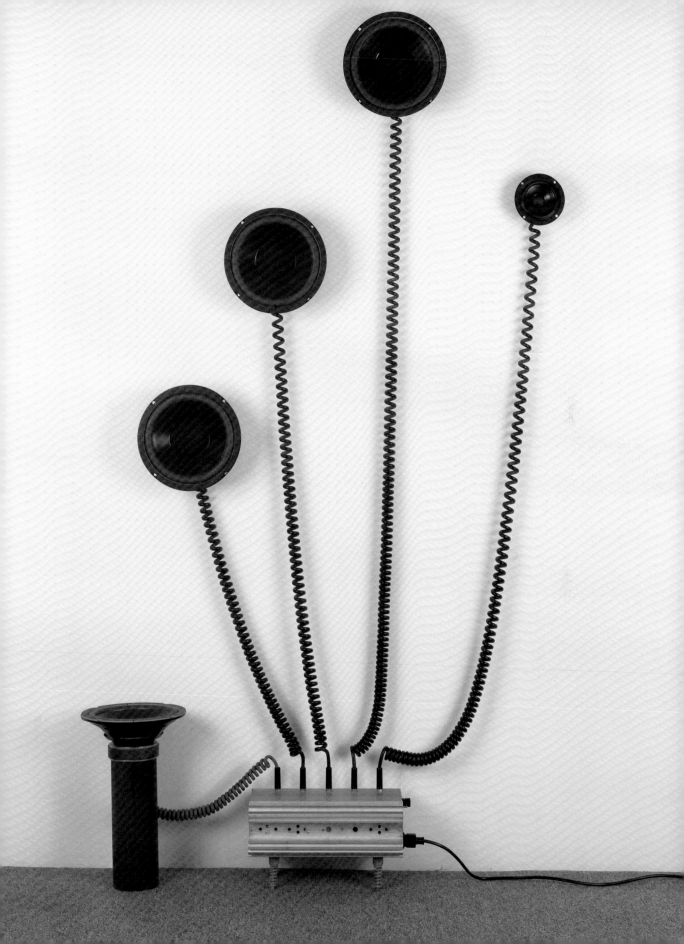

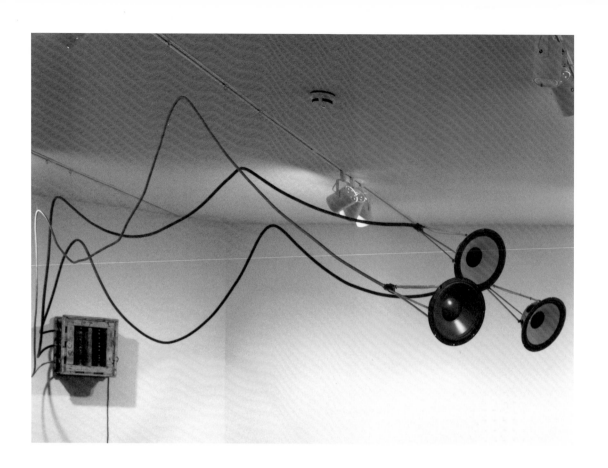

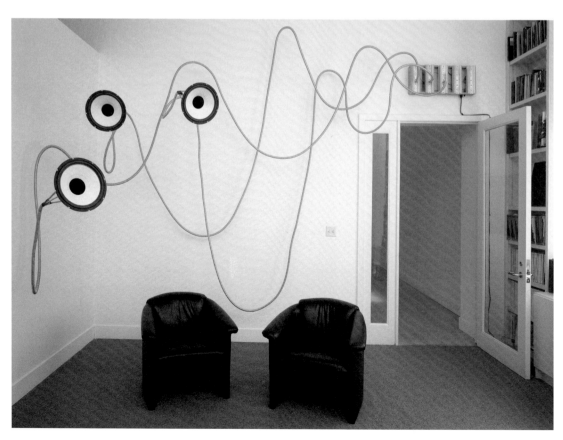

THE HOUND ON THE PLATEAU:
THE "TWITTERING MACHINES" OF ALAN RATH

> Render visible, Klee said; not render or reproduce the visible.
> — Gilles Deleuze and Felix Guattari, *A Thousand Plateaus*

Alan Rath's *Hound* (1990), rather than imitating a hound, evokes the idea of the animal within the technological. Two large twitching noses that appear on the exposed cathode ray tubes look to be pulling or leading the wooden wagon to which they are connected by cables. Low to the ground, sniffing for the trail, the "bloodhound"'s electronically generated sniffing noses embody the living within the means of the technological. The double irony of *Hound* is that its noses are human, not canine, and yet through the naming procedure of the title, they have become not the disembodied parts of a human form, but prosthetically attached to the primitive technology of the wagon.

The slippery signs of Rath's titles and the mixed metaphors of his sculptural forms, in *Hound*, *Birdie II* (1994), *Cyclops* (1992), and *Soar Eyes* (1994), suggest scurrying forms that live on the edges of a postmodern debate taking place today on the roles of science and technology at the *fin-de-siecle*. Central to this debate is a critique of the logic of progress which seeks to deconstruct the ideologies of a deterministic science. It is along the edges of this commentary that Rath's mixed-breed sculptures of high/low technology seem to play.

As I further thought about Rath's sculptures, I was reminded of two images from *A Thousand Plateaus: Capitalism and Schizophrenia,* by Gilles Deleuze and Felix Guattari: one image is a drawing of a wooden chariot from the Hermitage Museum described as a "Nomad Chariot, entirely of wood, Altai, Fifth to Fourth Centuries, B.C.," and the second is Paul Klee's watercolor, pen, and ink drawing *Twittering Machine* (1922). By juxtaposing the simple, direct drawing of a wagon whose advanced technology meant the rapid movement of the military across the plains of central Asia with Klee's evocation of the sound and image of an imaginary aviary, I want to suggest that the descriptive impulse behind the drawing of the chariot and the drawing that suggests (without describing) the aviary is joined in Rath's sculptural projects. The two drawings present, in their radical difference, what is expressed in Rath's elusively described imaginary creatures. Rath's sculptures evoke nomadic forms that move freely across the topographies of difference, between naming and the real, skillfully avoiding artificial divisions between media, materials, references, and meanings in a playful reconstruction of technology as a handmade medium.

Alan Rath's sculptures hold together disparate elements in a style that plays on the boundaries of description and materiality. As we enjoy the play of Rath's objects, we enter a world in which technology is a tension between the description of the real and the evocation of the poetic at the center of the real *and* imaginary.

John G. Hanhardt
Curator, Film and Video
Whitney Museum of American Art, New York

PHOTOS:

page 11

Bird Cage, 1985, 14 x 14 x 9 inches. Cage, electronics, cathode ray tube.
Private collection: California.

Birdie II, 1994, 14 x 6 x 9 inches. Plywood, fiberglass, aluminum, teflon, steel, servos, electronics, cathode ray tube.
Private collection: California.

page 12

Hound, 1990, 18 x 76 x 26 inches. Wood, steel, aluminum, electronics, two cathode ray tubes.
Walker Art Center, Minneapolis.

page 13

Cyclops, 1992, 16 x 51 x 44 inches. Wood, aluminum, electronics, cathode ray tube.
Private collection: Germany.

page 14

Bumper, 1990, 34 x 18 x 34 inches. Tripod, aluminum, electronics, speaker.
Private collection: California.

page 15

Ejector, 1992, 47 x 21 x 37 inches. Wood, aluminum, electronics, four speakers.

page 16

Soar Eyes, 1994, 9 x 32 x 45 inches. Aluminum, acrylic, electronics, two cathode ray tubes.
Private collection: Colorado.

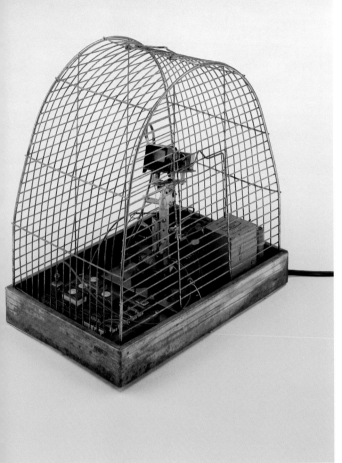

Straps

post

Square
Spindle
held up by
two right
angle brackets

Stepper

Stop

luz-1
groove
bearing

plywood
Circles

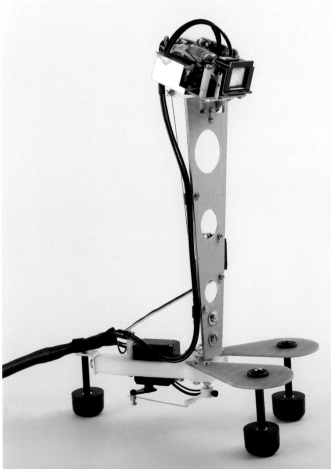

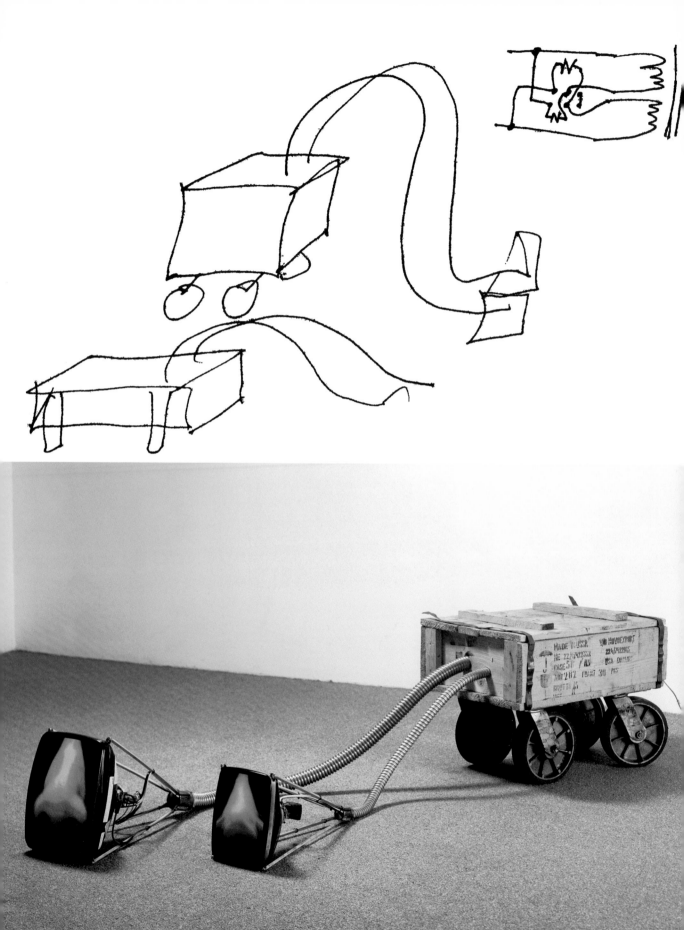

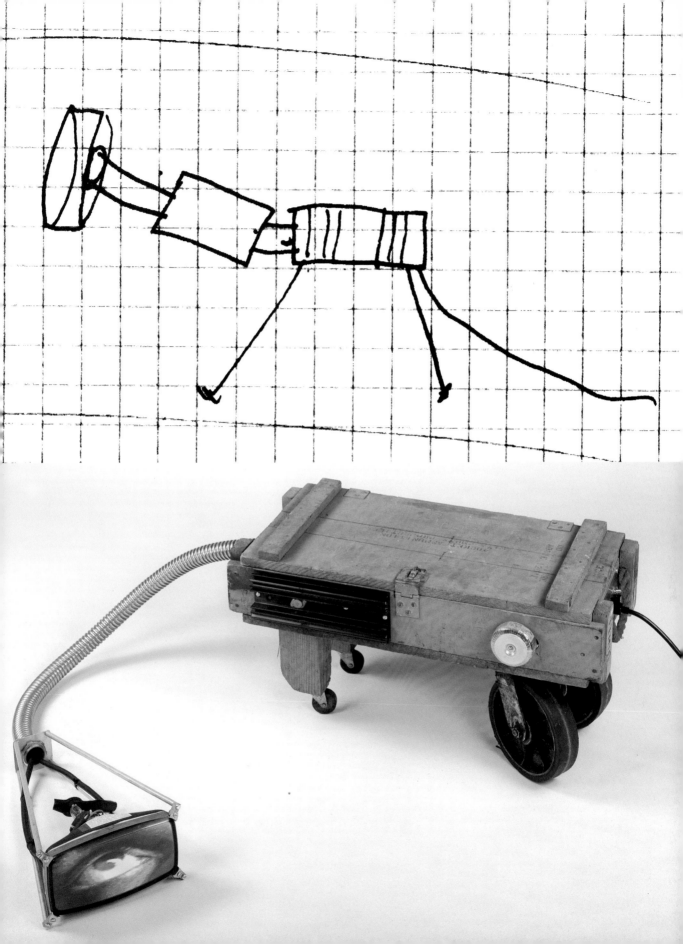

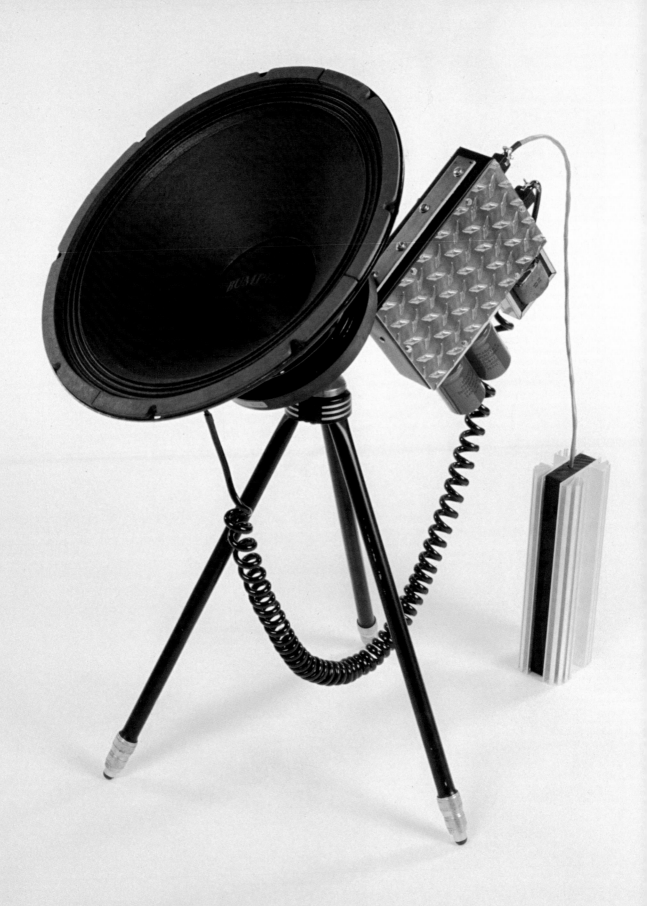

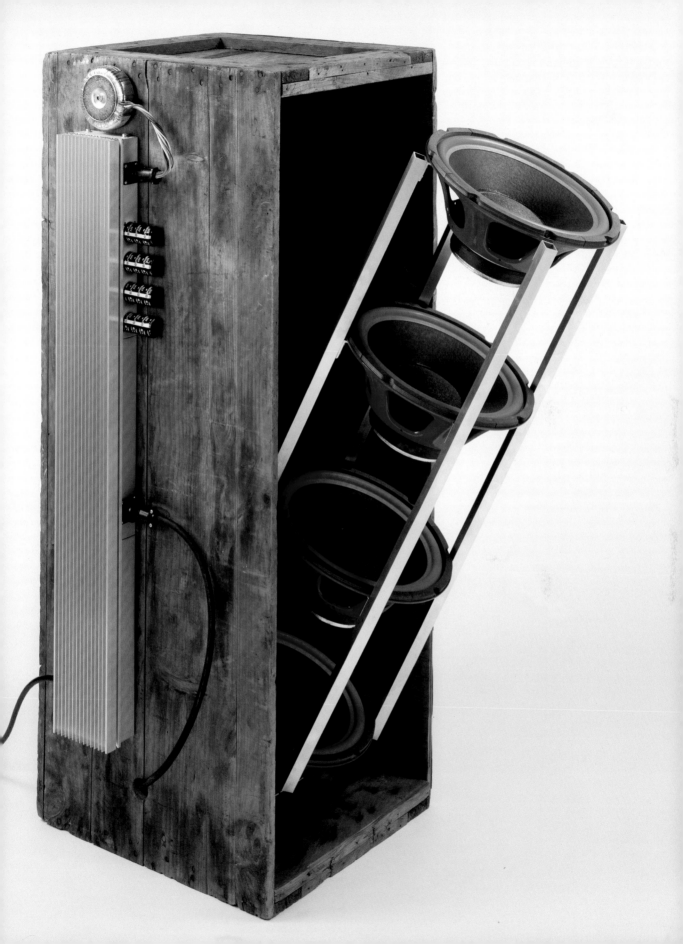

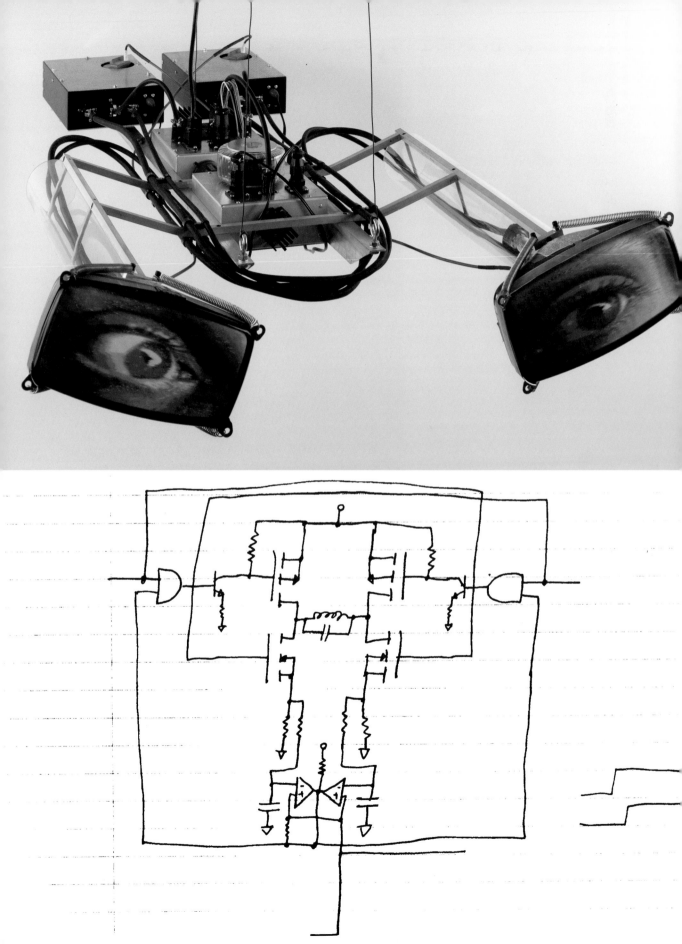

A HUMAN DIMENSION

Increasingly over past decades, technology has served as not only a primary tool in human endeavors, but, through electronic media, as a mirror in which we see the world and ourselves. Alan Rath manipulates electronics as both a formal and a metaphorical element in inventive video sculptures that comment on the symbiotic relationship between man and machine. However, his recent works have become more emotionally charged and self-reflective. Utilizing cathode ray tubes, exposed or encased electronic components, and found manmade objects, Rath eloquently renders a distinctly human representation. Despite the substitution of such "cold" artificial elements as wires, tubes, and plugs for organic sculptural materials, his pieces have an uncannily lifelike presence. The simple fragmented video images of chattering mouths, waving hands, rotating eyes, and closely cropped faces, as well as the elegantly gestural tubes and wires and the pulsating speakers, establish a powerful emotional rapport with the viewer. Along with female counterparts (with which they are sometimes paired), displays of Rath's own face, hand, eye, or mouth are often connected with wires and tubes resembling arteries to a "heart" of electronic inner-workings. Incorporated found objects also have bodily correlates in the skeletal posture of chairs, the torso-like medicine cabinets and suitcases, the rhythmic breathing of the stereo speaker, and the heartlike ticking of the clock. Furthermore, these objects operate as emotional and psychological metaphors, such as the suitcase/torso as the vessel for the heart and soul, or the mirrored *Vanity* as a representation of the inner and the outer self.

As the emphasis in Rath's work has shifted from social to self-referential, it has taken on a quality of anxious introspection. Elements such as clamps, vises, chains, handcuffs, and cagelike enclosures clearly indicate confinement and frustration. The tightly cropped video image of a grimacing face held fast by a large clamp dramatizes the mind's own rigidly imposed constraints. On the other hand, fragments of anatomy are sometimes loosely connected by long chains or cables, as if the connection between an intensely peering eye and an ineffectually waving hand (perceptions and action), or of a talking mouth and a pulsating chest (expression and emotion) are attenuated and polarized. Rath suggests an apparent power struggle between eye and hand, between thoughts and emotions, or between male and female in an implied relationship. A suitcase usually signifies the mobility of its bearer, but when handcuffed to a stationary chair or shackled by chains to an anxious face or to two talking mouths, this "baggage" carries the weight of one's own emotional history, of romantic entanglements, or of familial responsibilities. Paradoxically, many of the works seem to express both the desire to break free of such encumbrances, and the frustrating inability to fully integrate the polarities of mind, body, and heart. Rath's use of an electronic vocabulary to illustrate such classic human struggles reminds us that technology, despite its empowering capabilities, has done little to advance our ability to understand ourselves or to sustain emotional relationships.

Louis Grachos
Curator
Museum of Contemporary Art, San Diego

PHOTOS:

page 19

Vestigial Tail, 1994, 25 x 72 x 15 inches. Suitcase, handcuffs, chain, fluorescent lamp, electronics, speaker, cathode ray tube.

Train of Thought, 1994, 22 x 65 x 30 inches. Suitcase, clock, chain, fluorescent lamp, electronics, speaker, cathode ray tube.

page 20

Opposable Thumbs, 1986, 14 x 25 x 17 inches. Cage, aluminum, electronics, two cathode ray tubes.
Private collection: Spain.

Waiting II, 1989, 6 x 22 x 20 inches. Aluminum, electronics, cathode ray tube.
Private collection: California.

Clamped, 1992, 14 x 19 x 21 inches. Aluminum, electronics, cathode ray tube.
Private collection: Germany.

page 21

Spectator, 1989, 51 x 48 x 26 inches. Chair, steel, electronics, cathode ray tube.
Private collection: France.

page 22

Oral Fixation, 1992, 54 x 20 x 24 inches. Aluminum, steel, electronics, cathode ray tube.
Private collection: Germany.

page 23

Vanity, 1992, 43 x 39 x 20 inches. Wood, mirror, aluminum, electronics, cathode ray tube.
Private collection: Germany.

page 24

Man with Pink Suitcase, 1993, 43 x 32 x 17 inches. Stool, vise, suitcase, handcuffs, aluminum, fluorescent lamp, electronics, speaker, cathode ray tube.
Private collection: Massachusetts.

page 25

Fool Box, 1994, 16 x 48 x 36 inches. Toolbox, aluminum, electronics, speaker, cathode ray tube.

page 26

Family, 1994, 35 x 36 x 68 inches. Suitcases, handcuffs, chain, fluorescent lamps, electronics, three speakers, three cathode ray tubes.

page 27

Togetherness, 1995, 65 x 68 x 14 inches. Steel, wood, electronics, clock, two cathode ray tubes.
Private collection: Switzerland.

page 30

I Want, 1988, 25 x 29 x 82 inches. Aluminum, acrylic, motor, electronics, cathode ray tube.
Private collection: Hawaii.

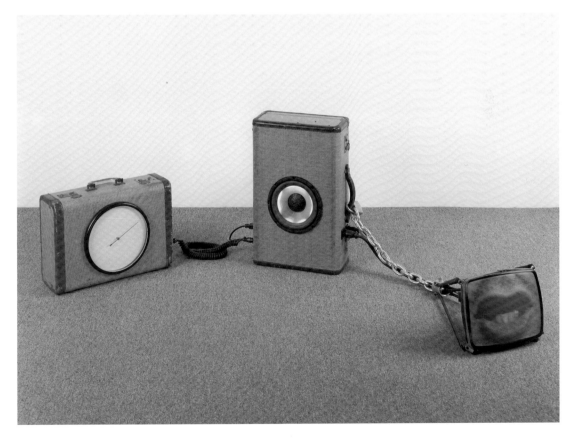

S.0B38

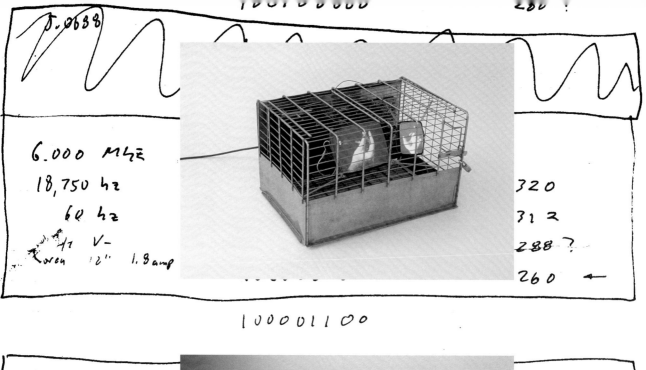

6.000 MHz
18,750 hz
60 hz
17 V-
Korea 12" 1.8 amp

320
31 2
288 ?
260 ⟵

10000l100

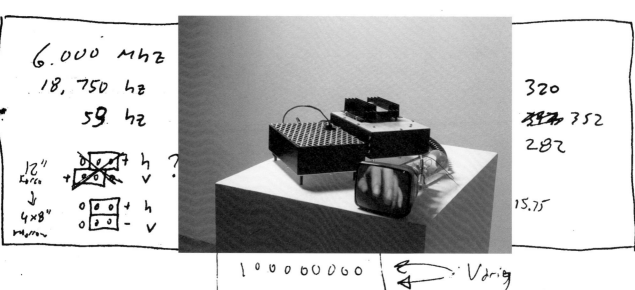

6.000 MHz
18, 750 hz
59 hz

12"
Korea 0 0 7 h ?
+ 0 0 0 v

4×8" 0 0 0 + h
mirror 0 0 0 − v

320
~~272~~ 352
282

15.75

100060060 ⟵ Vdrig

4×8 overscan
5.0B88 MHz
16,674
60

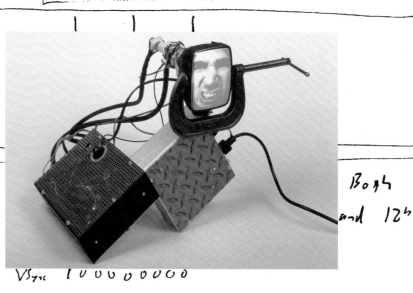

12" Korea overscan
17,600
60
not
quite

Both
and 12"

VSync 100000000

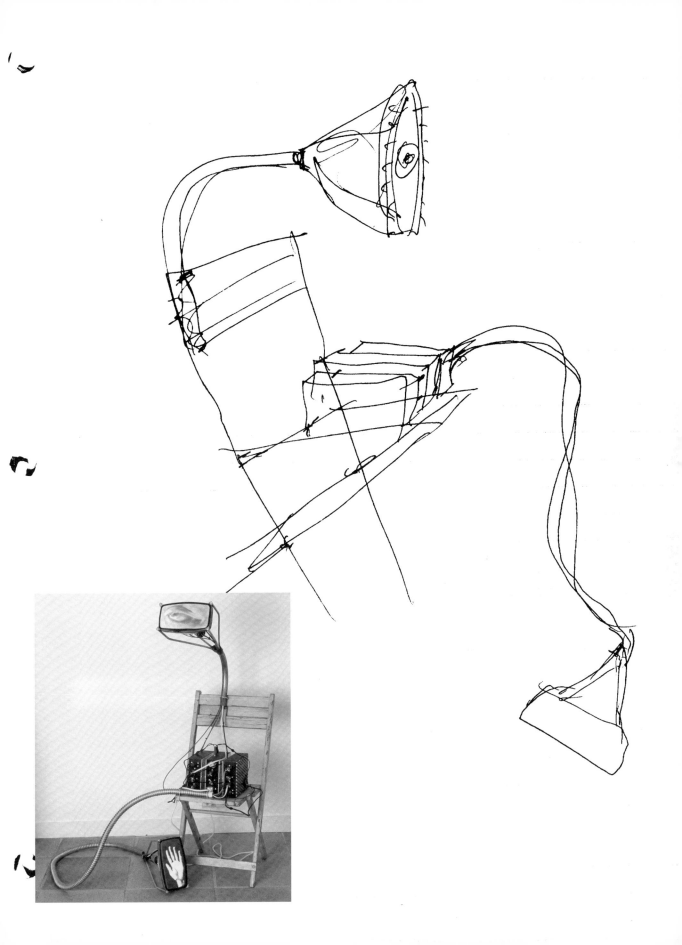

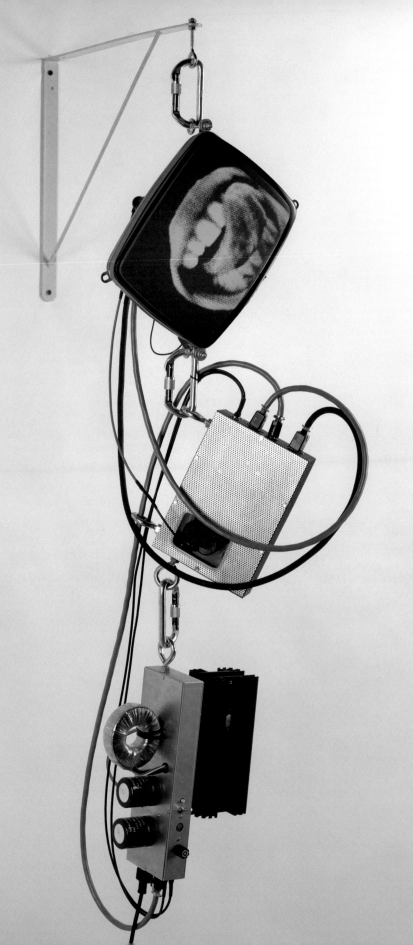

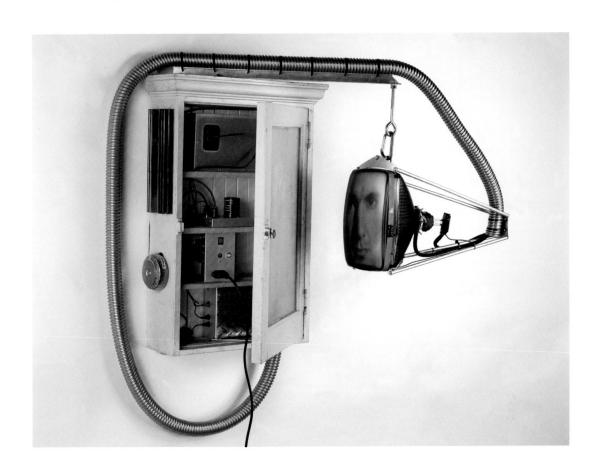

8/32

notch?

4-40

notch

does not work

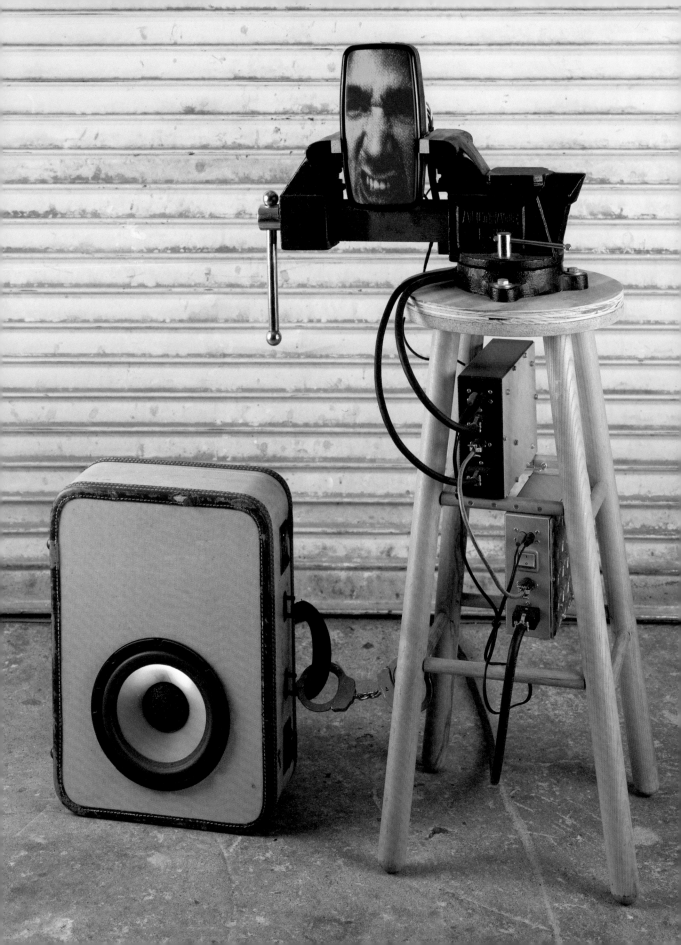

	5132	4.36	
2	ME4CN-100	2.25	80
1			
+			
100			
10			
10			
70			
10			
5			
5			9LB
5			3
10			14
5			14
10			-1
10			77
10	Q7104	2.18 ✓	
10	A SC10G-ND	9.36 ✓	144-4398
50 br	W183-ND	26.53 ✓	
10 br	W184-ND	7.12 ✓	
10 br	W185-ND	8.93 ✓	
10 br	W186-ND	9.86 ✓	
5	MM 74HC00N	1.40 ✓	
2	CD4046BE	1.88 ✓	
5	MM 74HC244N	3.00 ✓	
4	LM1875T	18.00 ✓	
+	~~LM338K~~	~~8.85~~	
+	~~LM350K~~	~~6.75~~ 80	
5	2438X	.52 ✓	
5	2.10KX	.52 ✓	
100	P2059 1.0µF 25v	23.10 ✓	
4/5	CD 74HC273G	~~2.45~~ 4.96 ✓	
2	DM74LS138N	1.82 ✓	
2	DM74LS373N	1.32 ✓	
2	~~SE408~~ CTX109	7.80 ✓	
100	P9820	10.99 ✓	
2		3.30	

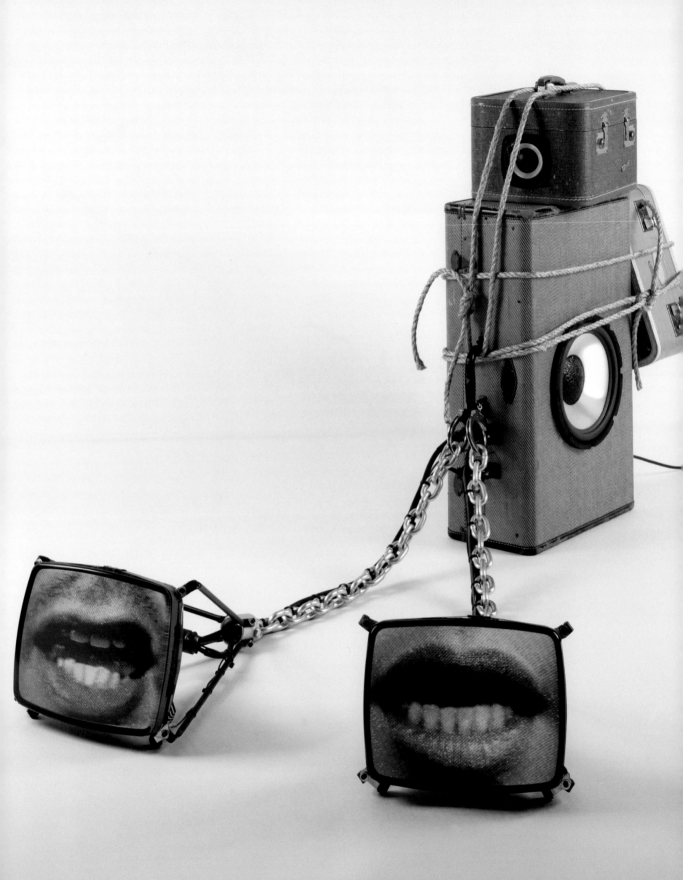

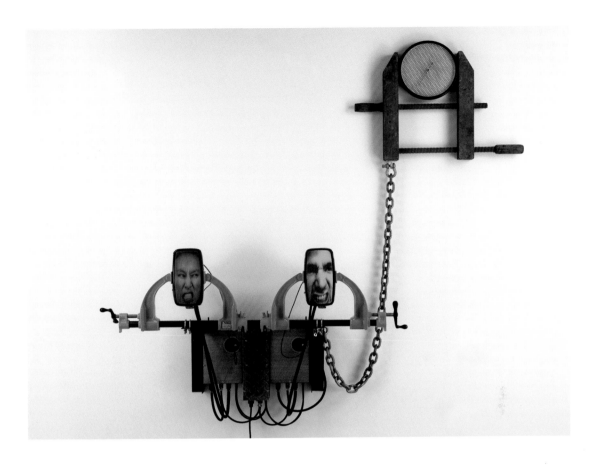

$$\int_0^3 (1-e^{-t})^2\,dt$$

$$\int^3 (1-2e^{-t}+e^{-2t})\,dt$$

$$t+2e^{-t}-\tfrac{1}{2}e^{-2t}\Big]_0^3$$

$$(3+.1-\sim)-(0+2-\tfrac{1}{2})=3.1-1.5=1.6$$

$$\text{mean} = \frac{1.6}{3} = .53 \qquad RMS = .73$$

? $RMS = \dfrac{.73+.41}{2} = .57$

.73 .41

3 6 t

Bad Idea!

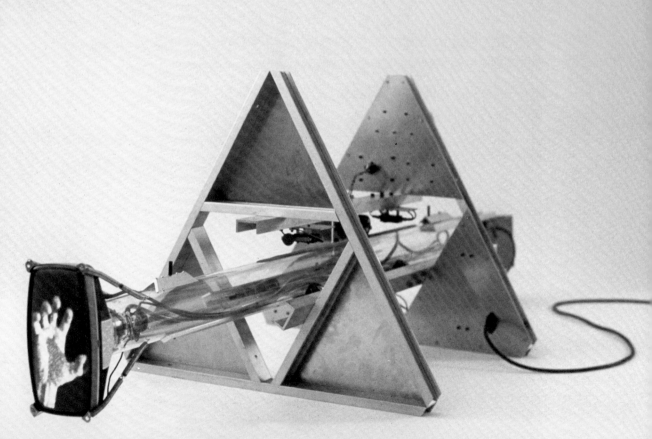

ALAN RATH: ART MACHINES

Technology is like your parents — it's a given and you have to learn to live with it. . . .
Our whole lives are immersed in technology, so we can't wish it didn't exist.
I can't comprehend what that would mean.[1]

Technology is both the subject and medium of Alan Rath's machines. It is this inseparability of form and content that sets his work apart from the vast bulk of technologically-based work that has come to dominate contemporary art. Most visual artists currently working with advanced technology seem to have come to their work via the influence of television, video games, or the personal computer. Their art is image-driven, the technology serving through a variety of means to animate the picture(s). Rath, on the other hand, either eschews the image altogether or incorporates it into a sculptural ensemble. For him, the image — when it is used at all — serves to animate the machine, rather than vice versa.

Rath's refusal to privilege the image over the machine stems in large part from the fact that he trained as an electrical engineer rather than as an artist.[2] For him, the machine and the ingenuity it manifests is a thing of beauty in and of itself. Rath, in other words, is in no small measure an unregenerate techie. "For me," he says, "using electronics . . . seemed analogous to [artists] fifty years ago using steel."[3] Mercifully, for those of us for whom anything beyond a lightbulb is an enigma, Rath is equally intrigued by the motives that lie behind our use and development of technology, and the dilemmas that arise as a consequence.

Early works such as *I Want*, *Pow,* and *Voyeur* underscore that in the development of technology up through the industrial age, the intention behind many of our machines was to amplify the powers of the physical body — to seize more, strike harder, or see farther, for example. With the coming of the computer age, the machine's function becomes more conceptual — to calculate faster, to gather and retain more information, to analyze more efficiently. Given that the computer was first developed to crunch numbers, it is not surprising that many of Rath's works — such as *You Can Make a Difference* or *Millenial Counter* — have to do with counting, something they do with an implacable persistence that seems to emphasize the meagerness of our individual existence.

A consistent focus of Rath's work is the apparent lag between technological innovation and our ability to cope with its implications. As he has put it, "We are living a lot more in the future than we want to acknowledge."[4] Particularly exemplary of this dilemma are works that deal with innovations in the field of medical science, such as *Bill, Bob and Barney*, *In Vitro*, *Animal Research*, and *Heartbeat*. In these works, the wit that often leavens Rath's production is notably missing. Perhaps for this reason they tend to be smaller in scale than other works, making them more meditative than confrontational.

The notable exception to this is *Challenger*, Rath's largest work to date. *Challenger* refers to the 1986 space shuttle disaster in which seven astronauts — including schoolteacher Christa McAuliffe, the first civilian selected to go into space — were incinerated before the eyes of the world. What fascinated Rath in this incident was both that it happened on live television, with millions of people (including schoolchildren) watching, and that it was a technological disaster apparently brought on by

the pressures created by technology — namely the mass media. McAuliffe's presence was intended as a public relations maneuver aimed at revitalizing flagging support for NASA's space program. But the repeated cancellations of the launch were threatening to turn the mission into a public relations fiasco, hence the pressure to launch the shuttle even under unfavorable conditions, a course of action that would never have been taken if the stakes had not been so high.

It is tempting to paint Rath as a moralist and his art machines as high-tech Cassandras warning of the dire consequences of our addiction to technology for technology's sake. The reality is a bit more ambiguous. "[Technology] is like a layer of culture or language," he has said. "It's something completely intertwined with our existence."[5] Rath's machines encourage us to recognize that technological innovation is inseparable from its human creators. For good or evil, the machine reflects the maker. But Rath does not stop there: his work goes on to suggest that, like language, our technology also shapes the way we perceive, understand, and act.

Peter Boswell
Associate Curator
Walker Art Center, Minneapolis

NOTES

1. Alan Rath interviewed by Mark J. Spencer in *Alan Rath* (Overland Park, Kans.: Johnson County Community College Art Gallery, 1993), unpag.

2. At the same time, it is worthwhile noting that Rath was attracted to the arena of electronic art via the field of music, rather than visual media. Certainly, the musical arts have been far more adept at convincingly and systematically incorporating technical innovation into their lexicons than have the visual arts. As a teenager, Rath singled out Jimi Hendrix as a paradigm of the electronic artist for his self-conscious emphasizing of aspects of electronic amplification — "accidents" like feedback and distortion — in his music. Even as a mature artist, Rath still contends he derives more inspiration from music than from visual arts (see note 1). Certainly this accounts for his homages to electronic music such as his "Guitar" series, or the shrine-like *Chinese Stereo* and the designer boom box *Travel Stereo*.

3. Quoted in the videotape *Viewpoints: Alan Rath* (Minneapolis, Minn.: Walker Art Center, 1991).

4. Quoted in Peter Boswell, *Alan Rath* (Minneapolis, Minn.: Walker Art Center, 1991), unpag.

5. Quoted in Donna Harkavy, *Insights: Alan Rath* (Worcester, Mass.: Worcester Art Museum, 1994), unpag.

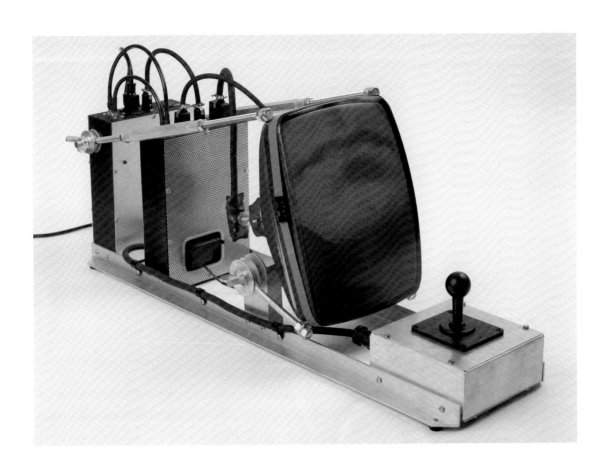

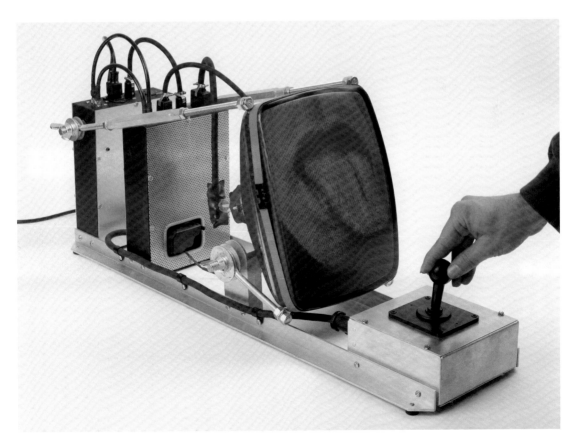

PHOTOS:

page 31
Joy Lick, 1994, 16 x 11 x 30 inches. Joystick, electronics, cathode ray tube.

page 33
Turbo Nose, 1990, 25 x 17 x 26 inches. Wheels, aluminum, electronics, cathode ray tube.
Private collection: Germany.

page 34
Apparat, 1990, 37 x 32 x 50 inches. Steel, wood, aluminum, electronics, two speakers.
Private collection: California.

page 35
Transmitter, 1990, 72 x 34 x 54 inches. Tripod, aluminum, electronics, four speakers.
Private collection: California.

pages 36, 37, 38
Challenger, 1991, 91 x 33 x 15 inches; 84 x 43 x 24 inches; 75 x 49 x 21 inches. Aluminum, steel,
LEDs, motors, computers, software, styrofoam balls, flag, lamps, electronics, seven cathode ray tubes.
Private collection: California. (photos courtesy Walker Art Center, Minneapolis)

page 40
Chinese Stereo, 1994, 102 x 83 x 14 inches. Painted wood, AM/FM/CD, electronics, speakers.

page 41
Twenty Month Counter, 1993, 6 x 8 x 3 inches. Display case, electronics, 8-digit LED display.
Millennial Box, 1994, 11 x 12 x 11 inches. Wood box, electronics, 12-digit LED display.

page 42
Travel Stereo, 1994, 24 x 57 x 14 inches. Suitcases, AM/FM/CD, motorized antenna, electronics,
speakers.

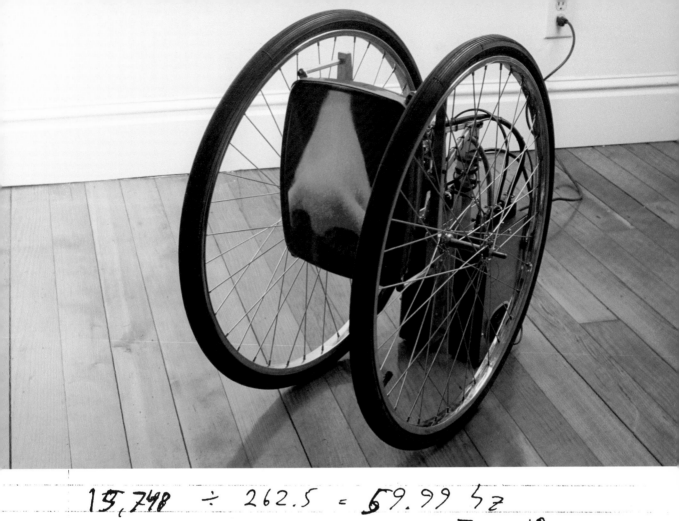

$$15,748 \div 262.5 = 59.99 \text{ Hz}$$

$$762 \times 525 = 400050$$

$$\frac{640 \times 480}{8} = 46,400$$

$$\frac{762 \times 525}{6}$$

$$66,675$$

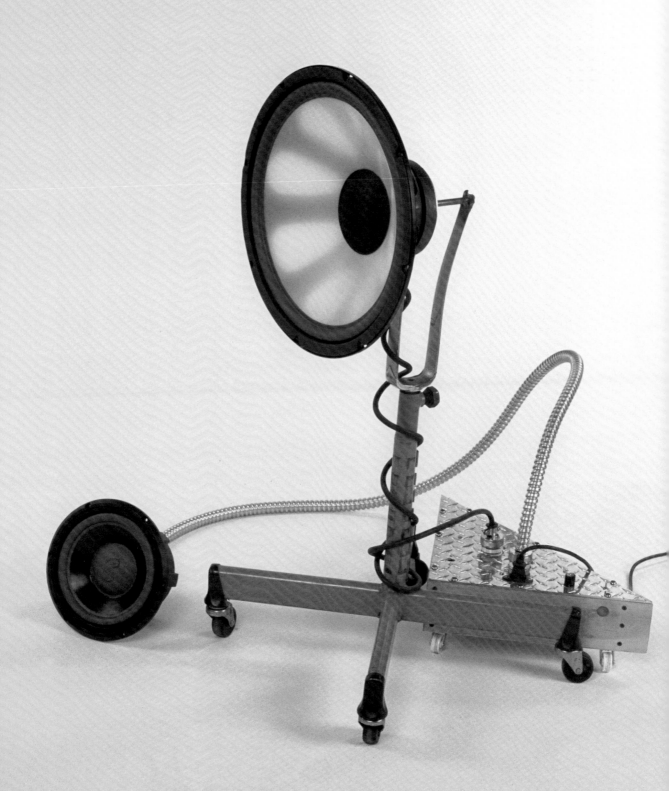

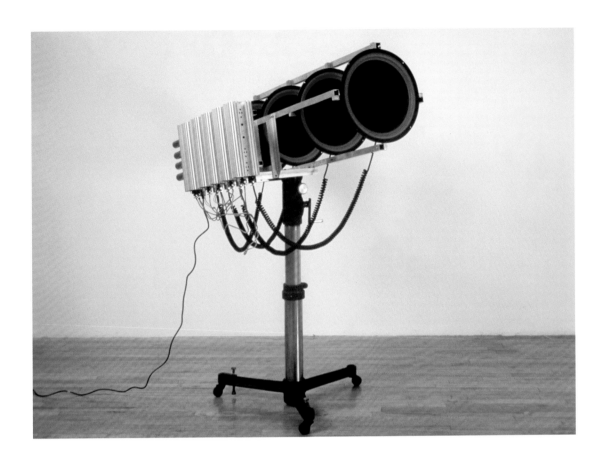

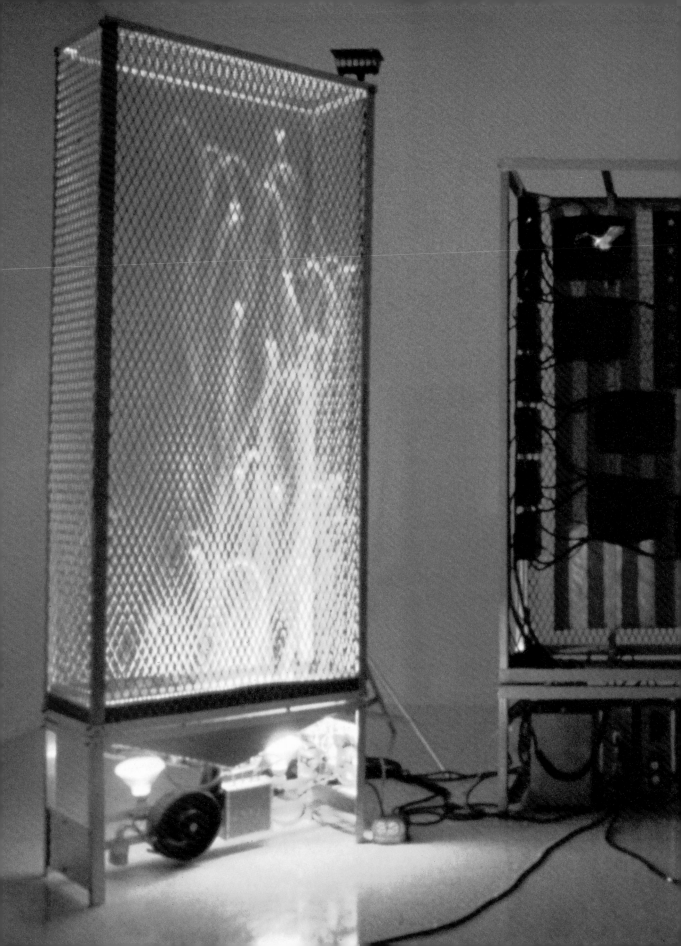

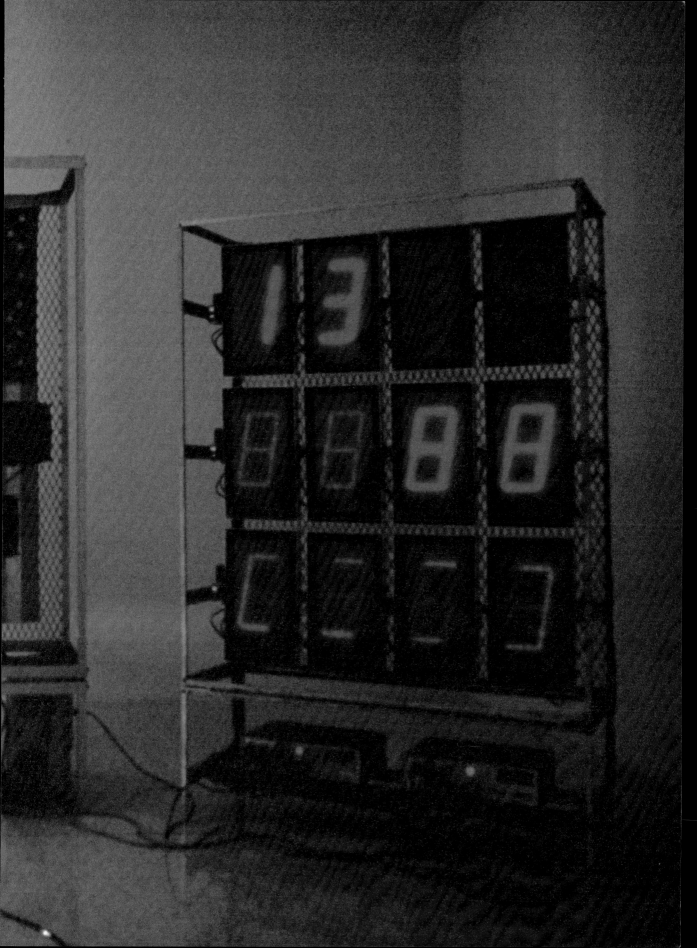

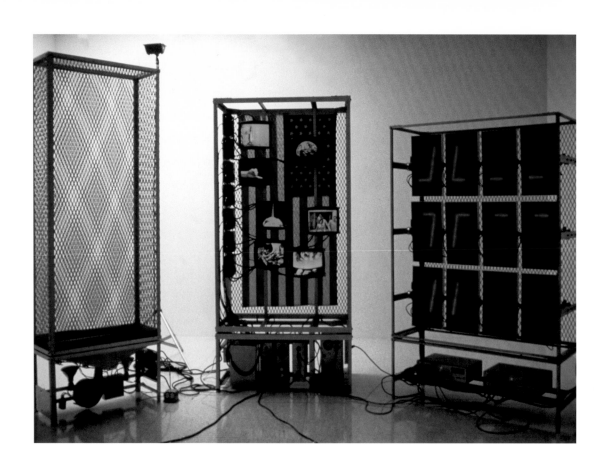

8736

Sink #1

$\frac{1}{2}$" depth

finish: black anodized overall
orientation: vertical
interface: bare $V_{in} = 20.0$ $A = 1.52$ $V_o =$

$T_A = 26.7$ $T_c = 71.8$ $T_{HS} = 60.0$

$P_0 = 12w$ $T_J = 72 + (12 \times 4) = 120$

$\theta_{cs} = \frac{12°}{12w} = 1 °/w$ $\theta_{SA} = \frac{60 - 27°}{12 w} = \frac{33°}{12w} \approx 3 °/w$

as above after more time to reach equilibrium

$T_A = 27$ $T_c = 77$ $T_{HS} = 67$

$V_0 = 11.3v$ $A = 1.5$ $P_0 = (20 - 11.3) 1.5 = 13w$

$\theta_{cs} = \frac{77 - 67}{13} = .77 °/w$ $\theta_{SA} = \frac{67 - 27}{13} = 3.1 °/w$

as above horizontal orientation

$P_0 = (20 - 11.3) 1.5 = 13w$

$T_A = 27$ $T_c = 79$ $T_{HS} = 69$

$\theta_{cs} = .77 °/w$ $\theta_{SA} = \frac{69 - 27}{13} = 3.2 °/w$

As above lower load

$P_0 = (20 - 12) .784 = 6.3w$

$T_A = 27$ $T_c = \cancel{60}$ 60 $T_{HS} = \cancel{} \,^{53}$

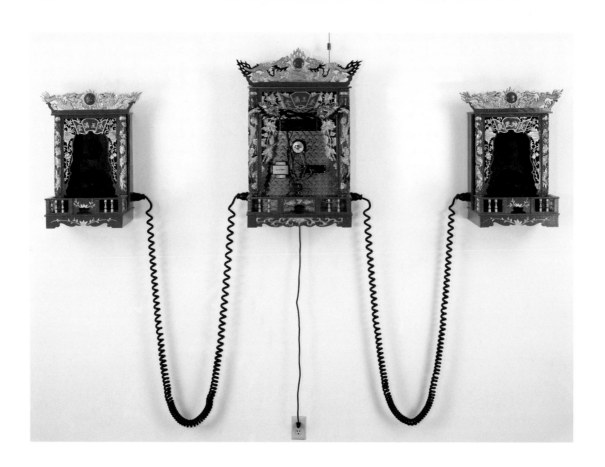

$$\lambda_p = \lambda_b \left(\pi_E + \pi_Q + \pi_c \right)$$

$$\lambda_b = A e^x \qquad x = \left(\frac{T_{HS} + 273}{N_T} \right)^6$$

$\pi_E = 1 \qquad$ ground
$\pi_Q = 20 \qquad$ commercial
$\pi_c = 1 \qquad$ fixed

$$T_{HS} = 25 + 1.1 (75) = 108$$

$$\lambda_b \approx .0015$$

$$\lambda_p = .0015 (20) = .03$$

$$\Delta T = 125 \frac{w}{A} = 125 \frac{I \cdot V}{4 \pi r l} = \frac{1.5 \times 7.5}{4 \pi (.625) 1.25} \qquad \frac{11.25}{9.8} \qquad 143$$

measured $\Delta T = 90$ $\qquad \frac{143}{90} = 1.6$

$$R_1 = \frac{12 \cdot 2.2k}{2.7v} - 2.2k = 9.8k$$

$$\int_0^{\frac{\pi}{2}} A \sin\theta \, d\theta$$

$$-A\cos\theta \Big]_0^{\frac{\pi}{2}} \qquad 0 - -A = A$$

80.64

4.03

mean $\rightarrow \dfrac{A}{\pi/2}$

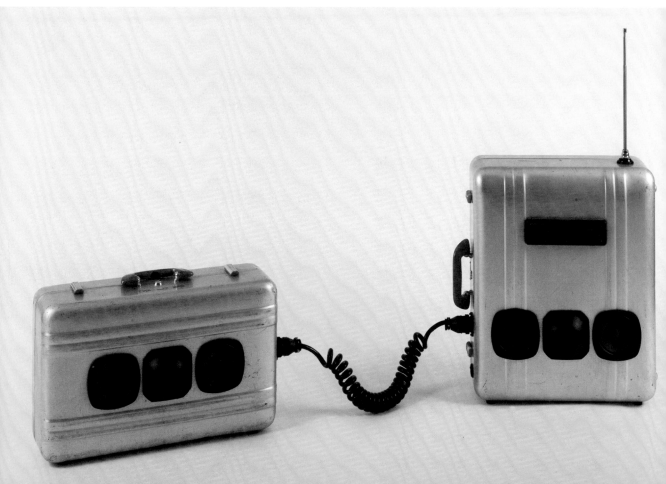

PLAY BACK BOARD

20 may 87

PLAYBACK

26-May-89

PLAY300 Top Overlay

PLAY300 Top Overlay

PLAY300 Top Layer

PLAY300 Top Layer

PLAY300 Bottom Layer

PLAY300 Bottom Layer

CHRONOLOGY

1959 born, Cincinnati, Ohio

1965 inserted hairpin in electrical outlet

1969 became interested in analog electronic music synthesizers

1971 started building transisterized circuits

1972 attended first rock concert

1975 designed and operated stage lighting for three-day outdoor rock music festival

1976 part-time job as assistant field service technician for mainframe computers

1978 moved to Boston for college

1979 traded kit-built synthesizer for roommate's kit-built computer

1980 first trip to Europe

1982 graduated, began work in multimedia/computer graphics industry

1983 quit job

1984 moved to California

1985 built first digital video sculptures

1986 abandoned homemade computers for generic XT

1987 freelanced in computer graphics hardware industry

1990 started to attend drag races

1991 first trip to Japan

1993 started building computer-controlled mechanical sculptures

1995 this book is published

BIOGRAPHY

Education:

1982 Massachusetts Institute of Technology, Cambridge
 Bachelor of Science in Electrical Engineering

Selected Solo Exhibitions:

1995 Haines Gallery, San Francisco
1994 Hiroshima City Museum of Contemporary Art, Hiroshima, Japan
 Worcester Art Museum, Worcester, Mass.
 John Weber Gallery, New York
1993 Gallery of Art, Johnson County Community College, Overland Park, Kans.
 Southeastern Center for Contemporary Art, Winston-Salem, N.C.
1992 Galerie Hans Mayer, Düsseldorf, Germany
1991 Carl Solway Gallery, Cincinnati
 Walker Art Center, Minneapolis
 traveled to: Museum of Contemporary Art, Chicago; Institute of Contemporary Art, Philadelphia; Center for the Fine Arts, Miami; The Contemporary Museum, Honolulu
1990 San Jose Museum of Art, San Jose
 Dorothy Goldeen Gallery, Santa Monica
1988 New Langton Arts, San Francisco
1987 ProArts, Oakland
1986 Artists' Television Access, San Francisco
 WORKS/San Jose, San Jose

Selected Group Exhibitions:

1995 Aldrich Museum of Contemporary Art, Ridgefield, Conn.
1994 Spiral Art Center, Tokyo, Japan
 MIT Museum, Cambridge
1993 Akademie der Künste, Berlin, Germany
 International Center of Photography, New York
1992 Padiglione d'Arte Contemporanea, Ferrara, Italy
 International Center of Photography, New York (traveled)
 Aalvar Alto Museum, Jyvaskyla, Finland
 Thread Waxing Space, New York
1991 Whitney Museum of American Art, New York
 Denver Art Museum, Denver
1990 San Francisco Museum of Modern Art, San Francisco
 Stadtmuseum Siegburg, Siegburg, Germany
 Oakland Museum, Oakland
 San Diego Museum of Art, San Diego
1989 Ars Electronica, Linz, Austria
 Visiona, Zurich, Switzerland
1988 San Francisco Museum of Modern Art, San Francisco
 Badischer Kunstverein, Karlsruhe, West Germany
 Center for the Fine Arts, Miami
 San Francisco Camerawork Gallery, San Francisco (traveled)
1987 Everson Museum of Art, Syracuse (traveled)
1986 San Francisco International Video Festival, San Francisco

Fellowships:

1994 John Simon Guggenheim Memorial Foundation
1988 National Endowment for the Arts

MANY MONTHS AGO, perhaps a year, almost pre-Smart Art Press, we sought an opportunity to produce a catalogue with ALAN RATH. We are true "fans" of Alan's work — which we see as a combination of know-how, mind-boggling technical expertise, a social conscience, a good-old-fashioned sense of humor, and the ability to combine the essence of each in an individual work of art, repeatedly. Without repeating himself.

But I extoll.

Do this: enjoy the catalogue, and come to Track 16 Gallery to see Alan Rath's "CHALLENGER" during the L.A. INTERNATIONAL this summer. Oh, and subscribe to Smart Art Press.

☐ I'm subscribing/resubscribing immediately. Here's $120 for the next 10 catalogues
 (Vol. 2, Nos. 11-20) plus X-TRA STUFF.

☐ Okay, okay, I want the first ten, too (plus X-TRA STUFF). Here's another $120.

#1. Burt Payne 3: Access #6. Joe Zucker: A Decade of Paintings
#2. Wheels #7. Fool's Paradise
#3. Jim Butler: Paintings #8. Jim Shaw: Dreams
#4. Murder #9. Alan Rath: Plants, Animals, People, Machines
#5. The Short Story of the Long
 History of Bergamot Station

Coming up: • EATS: An American Obsession
 • North Viet Nam Propaganda Art, 1969-1980
 • Joseph Bertiers: The View From Nairobi
 • MAN RAY: Paris/L.A.
 • Dialogo/Dialogue/Comhra: An Exhibition of Contemporary
 Work by Irish, Mexican, and Chicano Artists

☐ I remain unconvinced, but I'll take a Track 16 hat for ten bucks.

NAME_____

ADDRESS_____

PHONE_____

CREDIT CARD_____

SIGNATURE_____ EXP DATE____

SMART ART PRESS

2525 MICHIGAN AVE BUILDING C SANTA MONICA, CA 90404
PHONE 310-264-4678 FAX 310-264-4682

MANY MONTHS AGO, perhaps a year, almost pre-Smart Art Press, we sought an opportunity to produce a catalogue with ALAN RATH. We are true "fans" of Alan's work — which we see as a combination of know-how, mind-boggling technical expertise, a social conscience, a good-old-fashioned sense of humor, and the ability to combine the essence of each in an individual work of art, repeatedly. Without repeating himself.

But I extoll.

Do this: enjoy the catalogue, and come to Track 16 Gallery to see Alan Rath's "CHALLENGER" during the L.A. INTERNATIONAL this summer. Oh, and subscribe to Smart Art Press.

☐ I'm subscribing/resubscribing immediately. Here's $120 for the next 10 catalogues (Vol. 2, Nos. 11-20) plus X-TRA STUFF.

☐ Okay, okay, I want the first ten, too (plus X-TRA STUFF). Here's another $120.

#1. Burt Payne 3: Access
#2. Wheels
#3. Jim Butler: Paintings
#4. Murder
#5. The Short Story of the Long History of Bergamot Station
#6. Joe Zucker: A Decade of Paintings
#7. Fool's Paradise
#8. Jim Shaw: Dreams
#9. Alan Rath: Plants, Animals, People, Machines

Coming up:
- EATS: An American Obsession
- North Viet Nam Propaganda Art, 1969-1980
- Joseph Beltiers: The View From Nairobi
- MAN RAY: Paris/L.A.
- Dialogo/Dialogue/Comhra: An Exhibition of Contemporary Work by Irish, Mexican, and Chicano Artists

☐ I remain unconvinced, but I'll take a Track 16 hat for ten bucks.

NAME _____

ADDRESS _____

PHONE _____

CREDIT CARD _____

SIGNATURE _____ EXP DATE _____

SMART ART PRESS

2525 MICHIGAN AVE BUILDING C SANTA MONICA, CA 90404
PHONE 310-264-4678 FAX 310-264-4682